Adult Coloring Book

MARJORIE FLOHR

Copyright © 2016 Marjorie Flohr.

All rights reserved. No part of this book may be used or reproduced by any means, graphic, electronic, or mechanical, including photocopying, recording, taping or by any information storage retrieval system without the written permission of the author except in the case of brief quotations embodied in critical articles and reviews.

Archway Publishing books may be ordered through booksellers or by contacting:

Archway Publishing
1663 Liberty Drive
Bloomington, IN 47403
www.archwaypublishing.com
1 (888) 242-5904

Because of the dynamic nature of the Internet, any web addresses or links contained in this book may have changed since publication and may no longer be valid. The views expressed in this work are solely those of the author and do not necessarily reflect the views of the publisher, and the publisher hereby disclaims any responsibility for them.

Any people depicted in stock imagery provided by Thinkstock are models,
and such images are being used for illustrative purposes only.
Certain stock imagery © Thinkstock.

ISBN: 978-1-4808-2902-2 (sc)
ISBN: 978-1-4808-2901-5 (e)

Print information available on the last page.

Archway Publishing rev. date: 11/29/2017

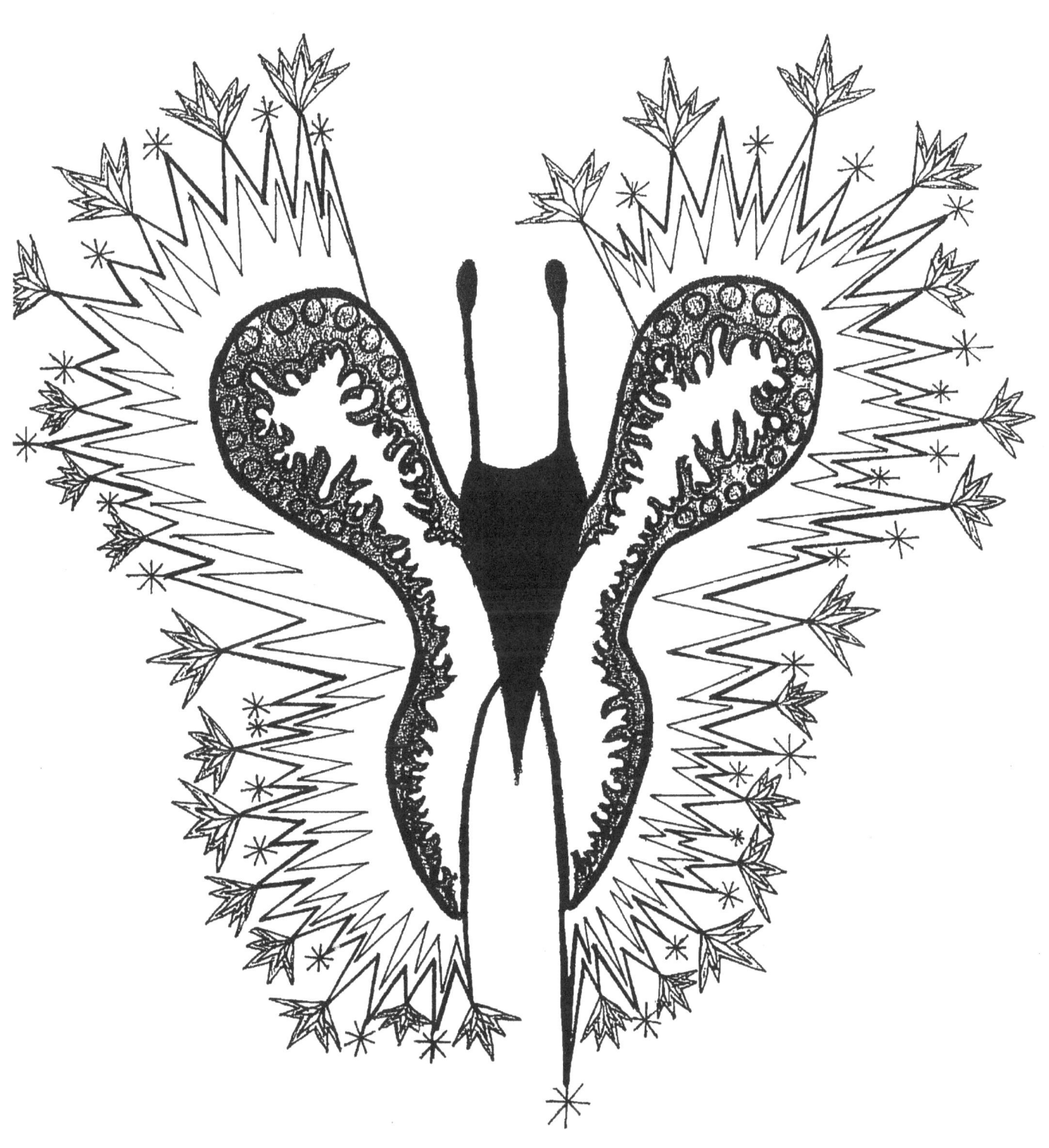

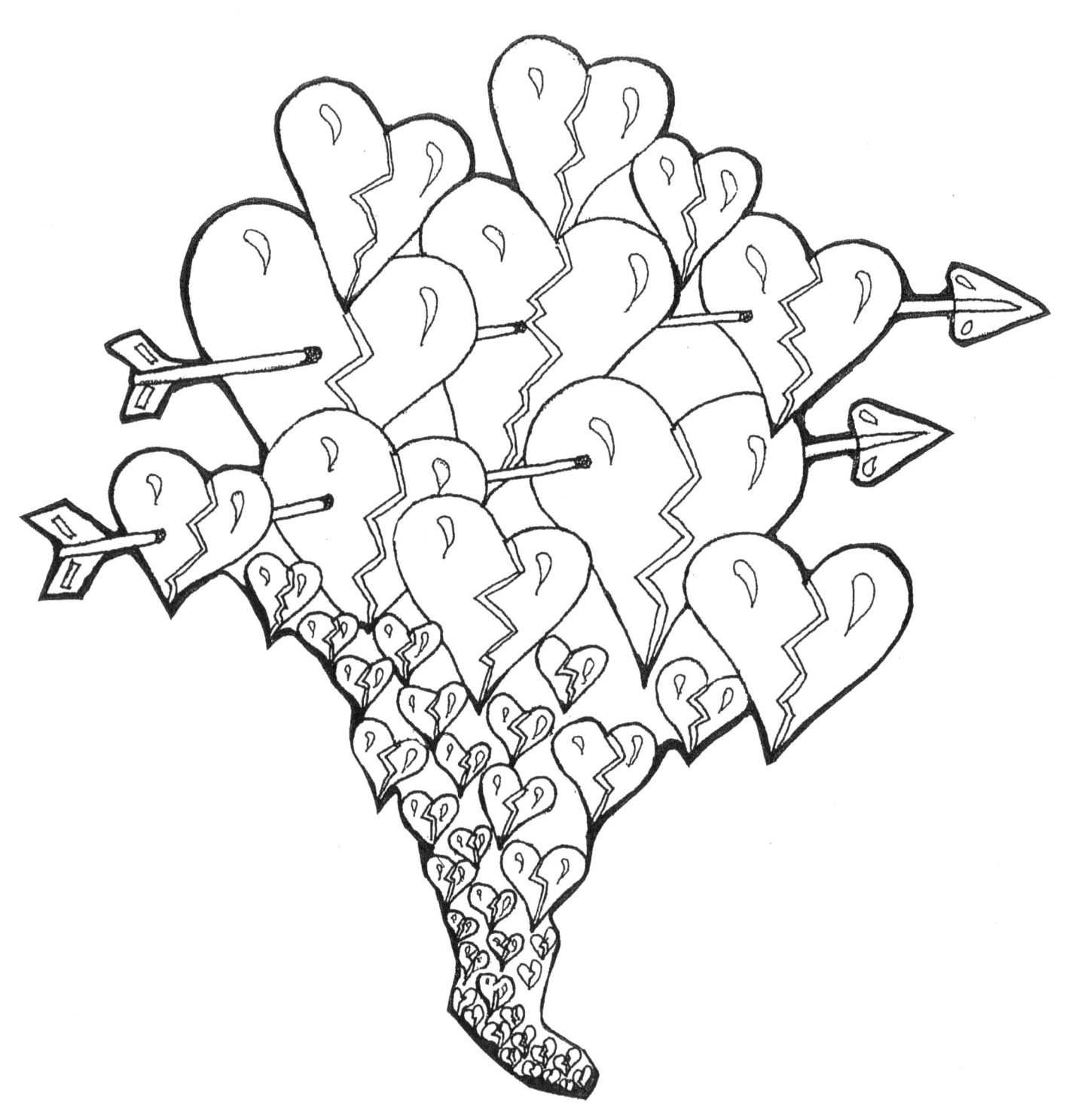

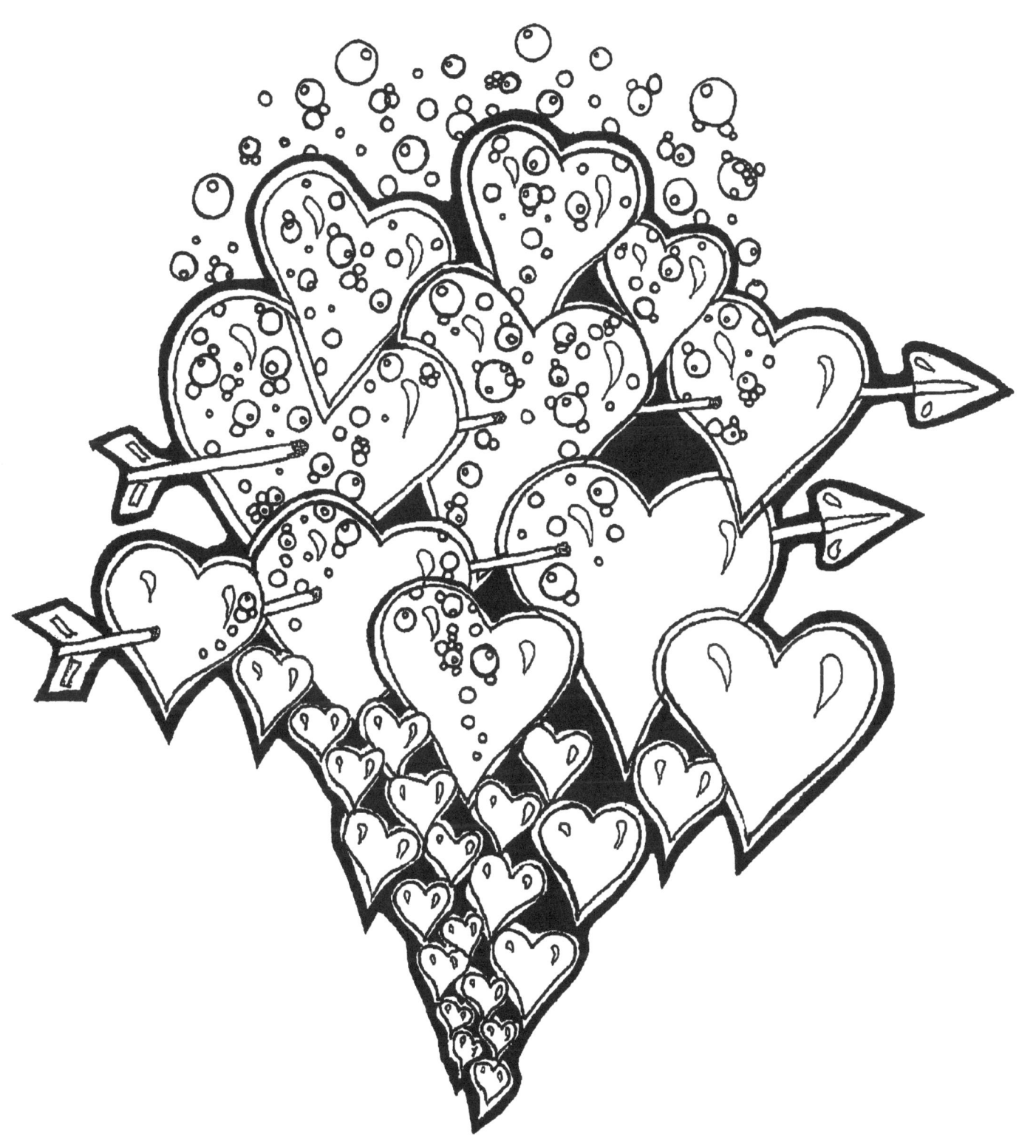

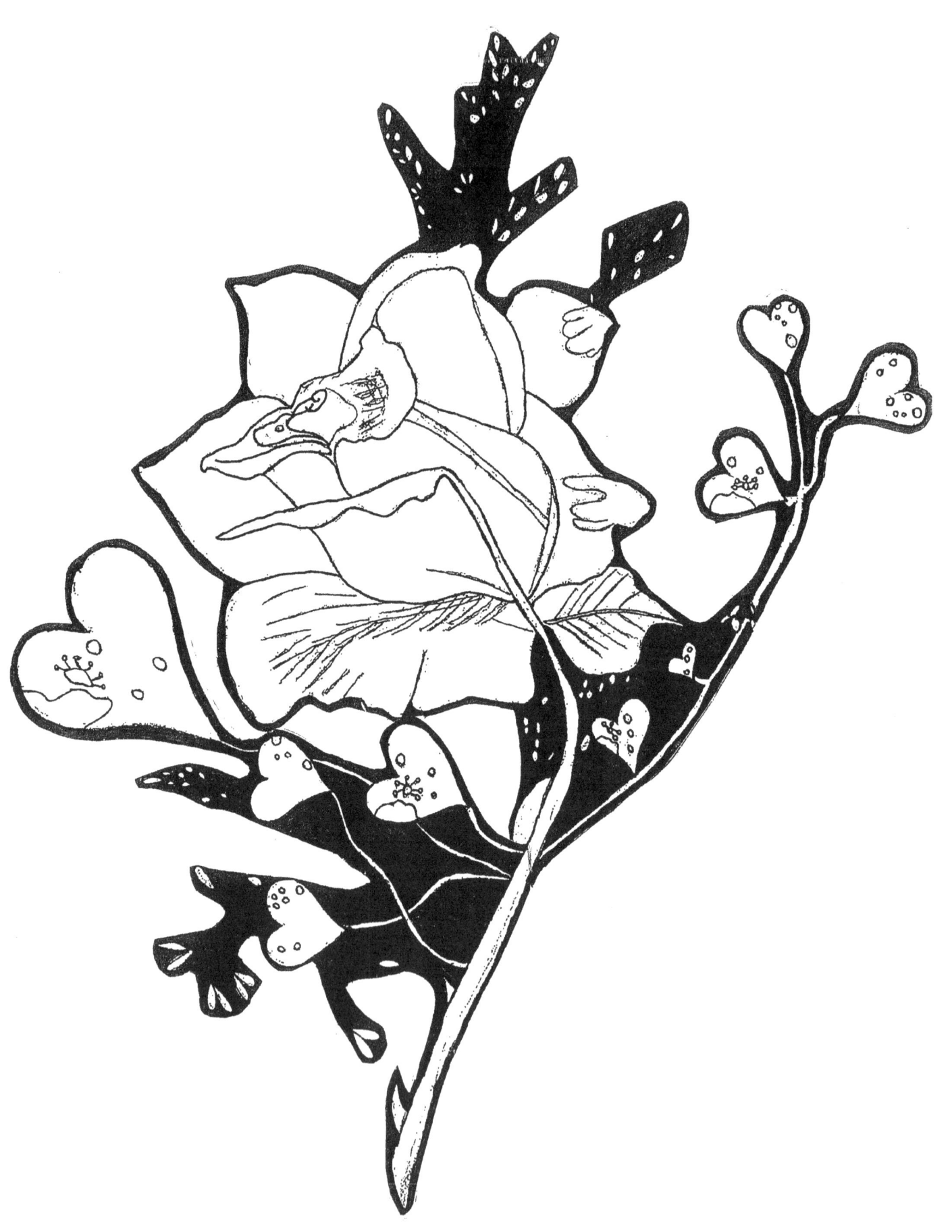

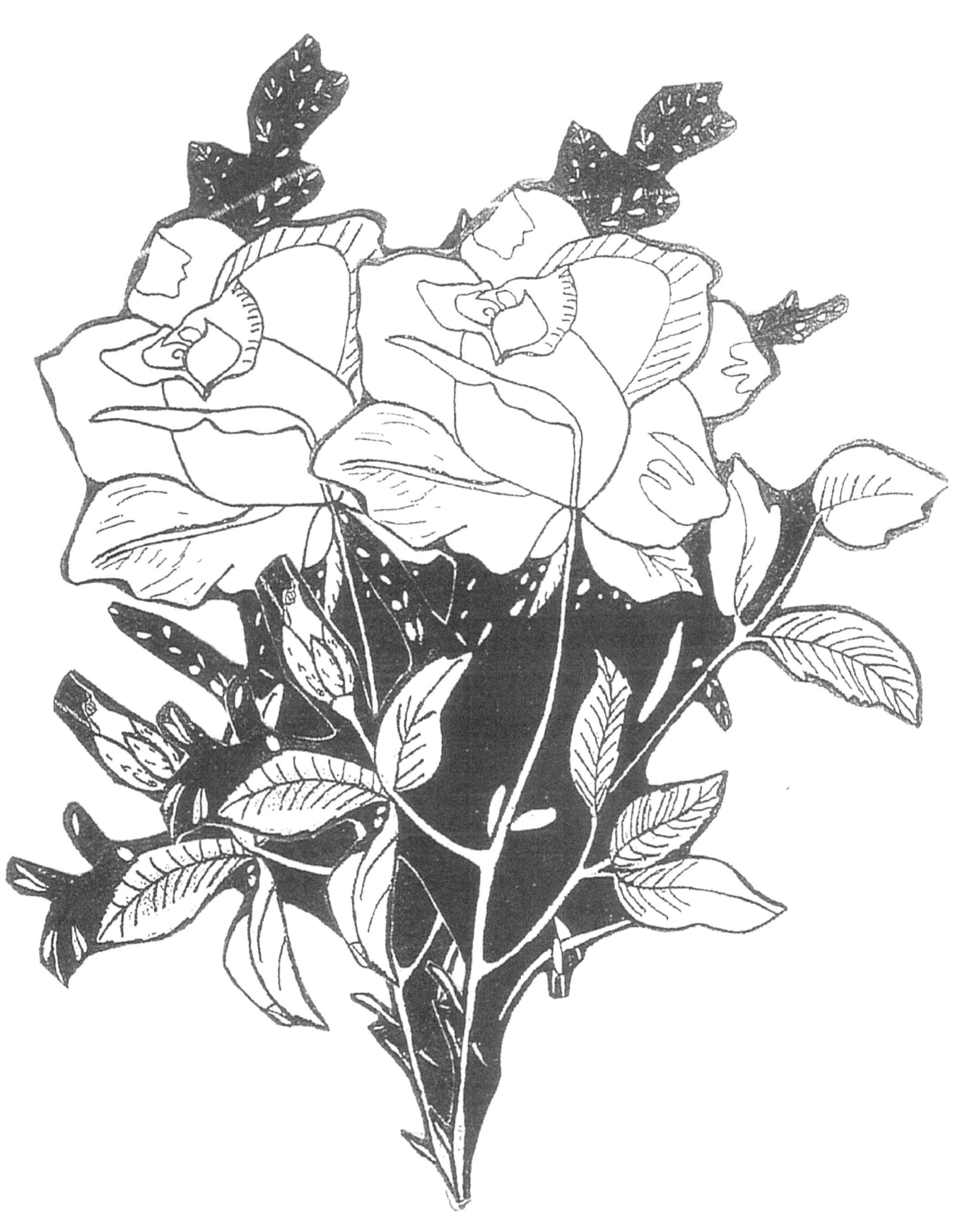

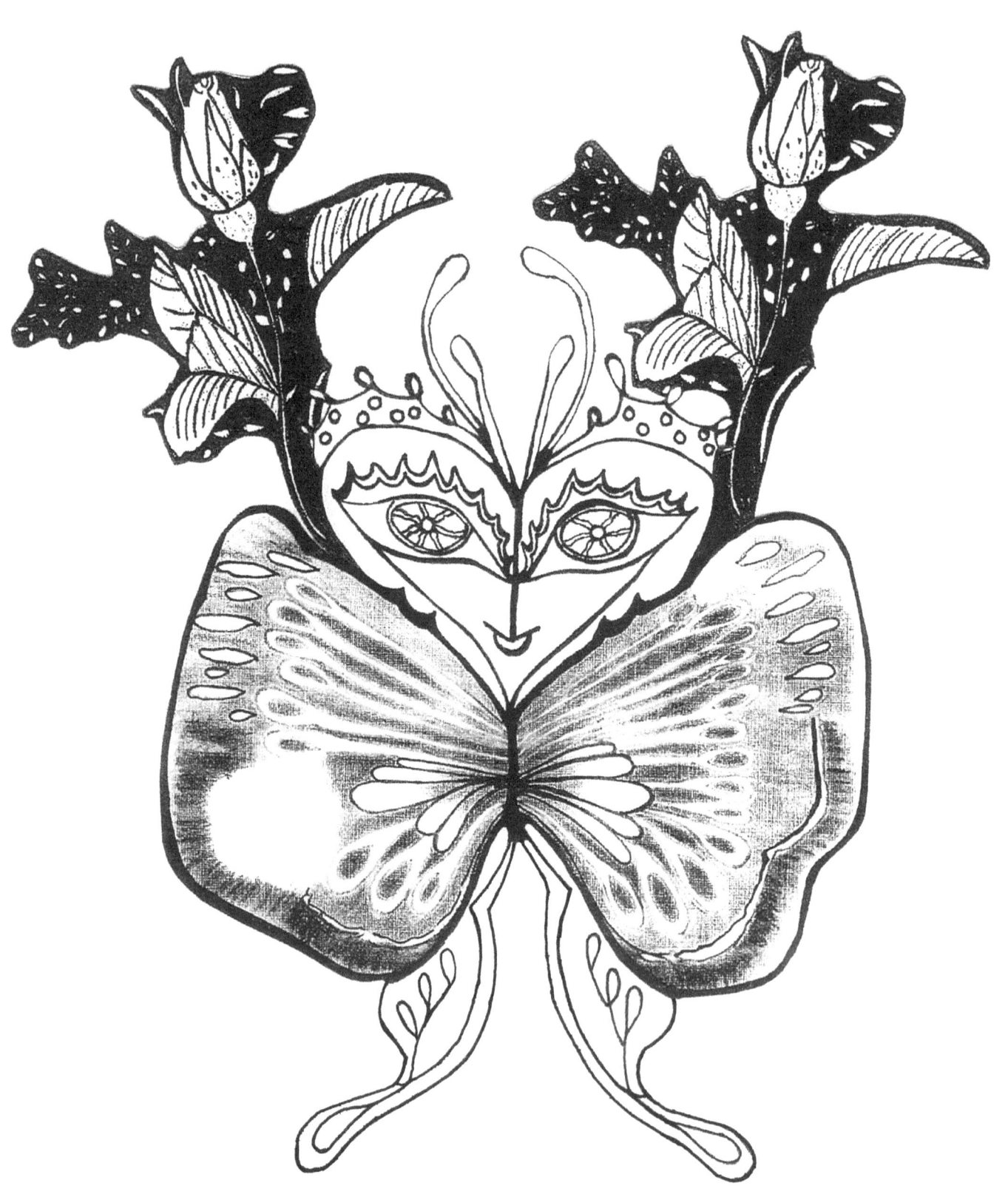

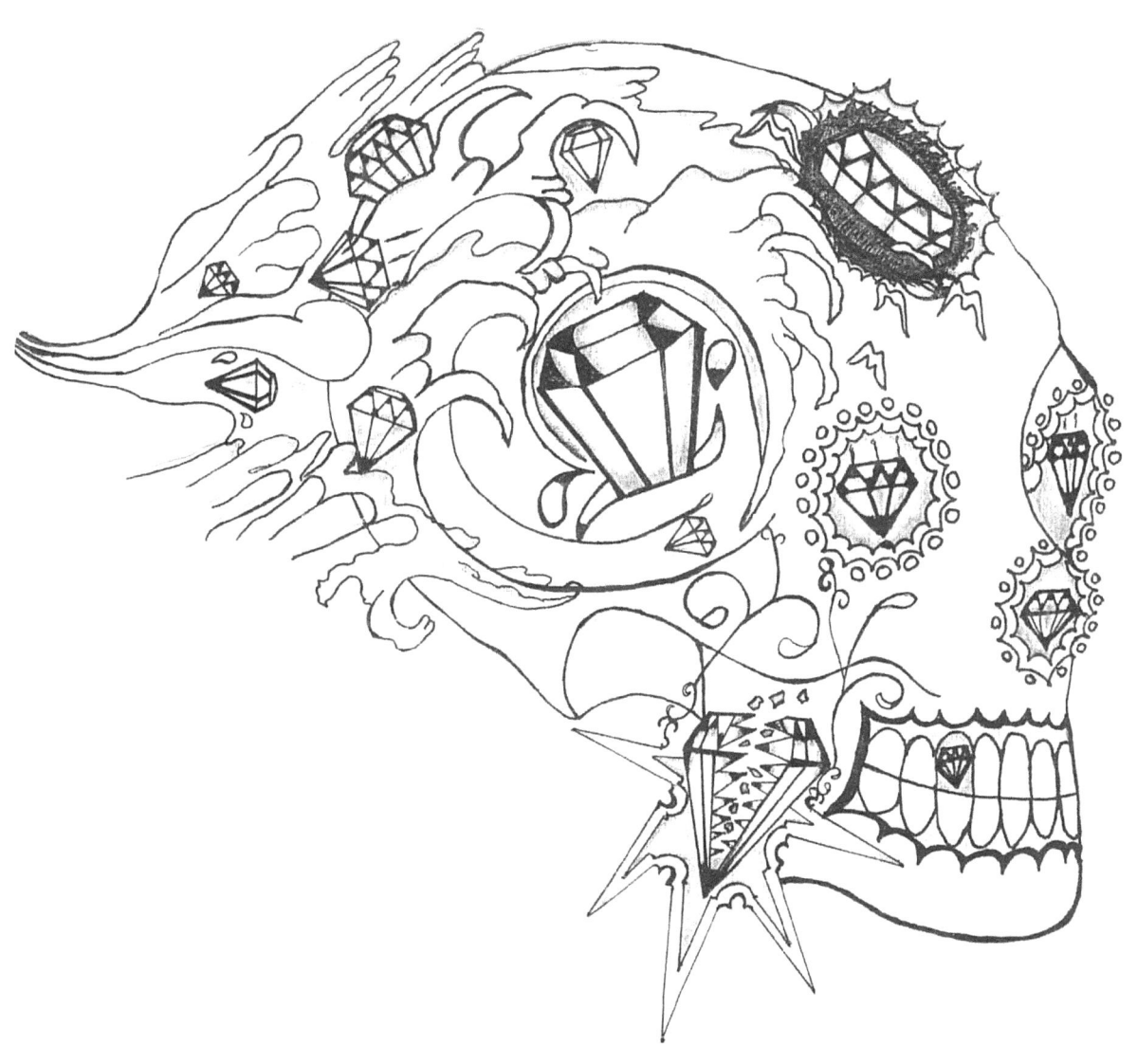

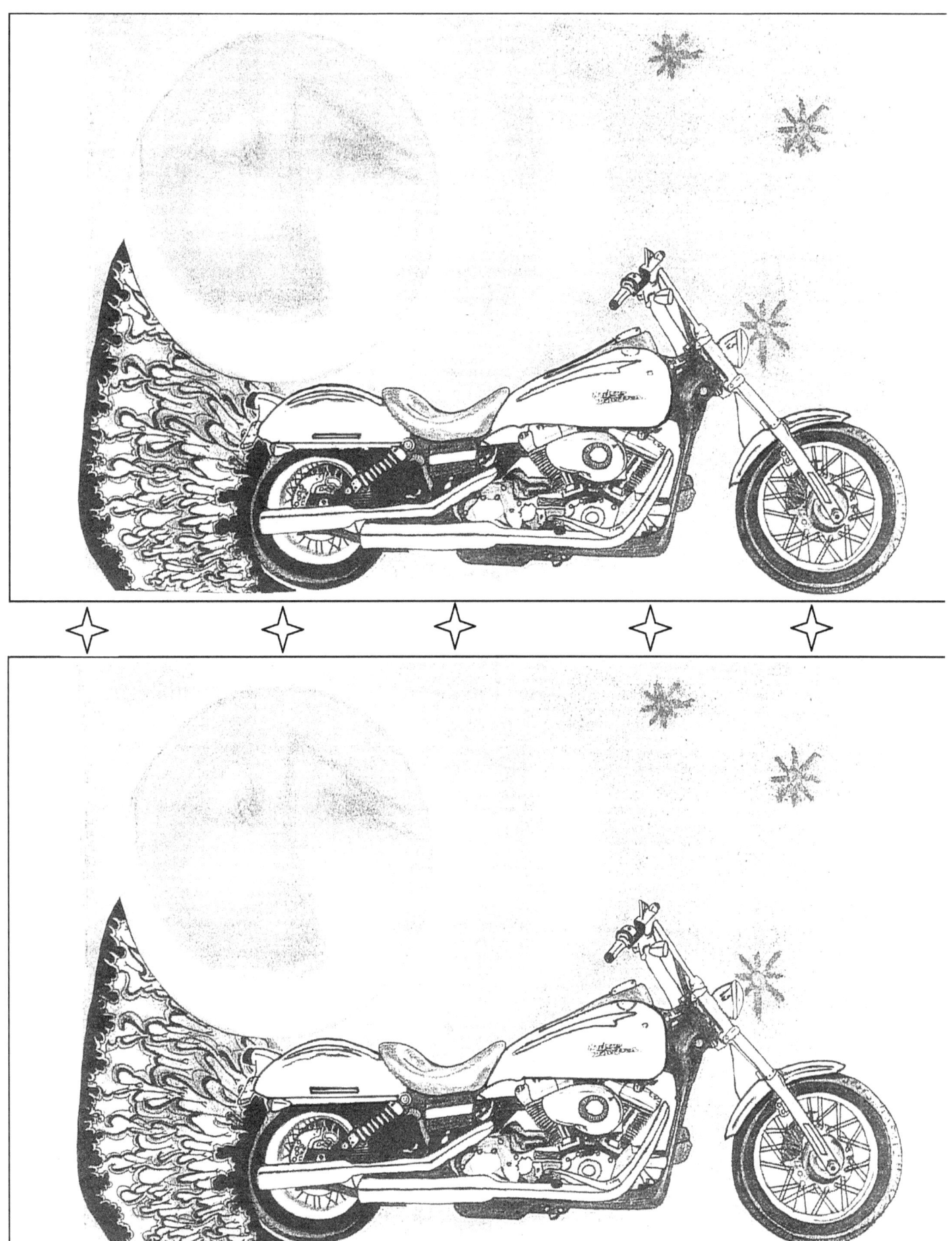

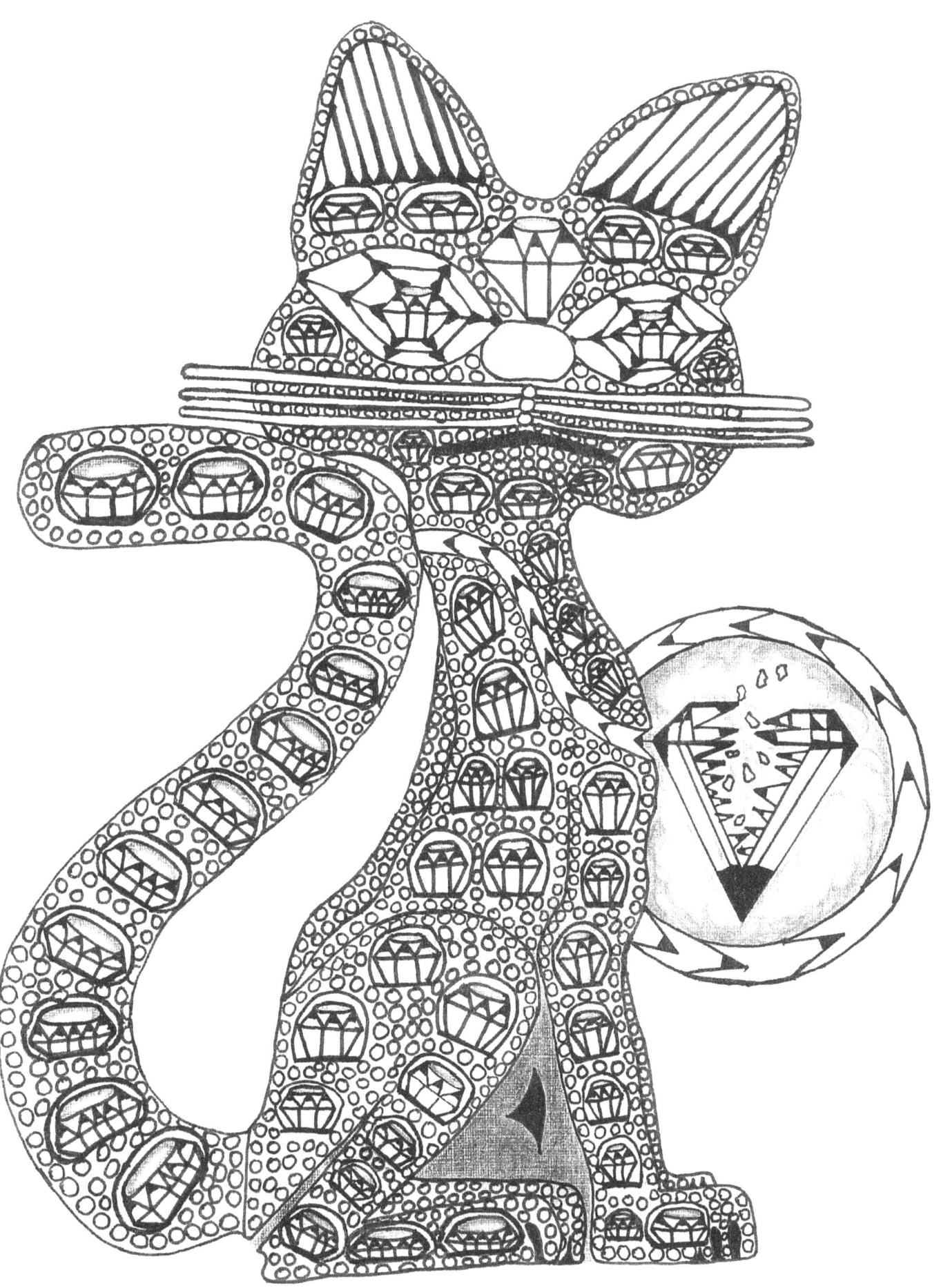

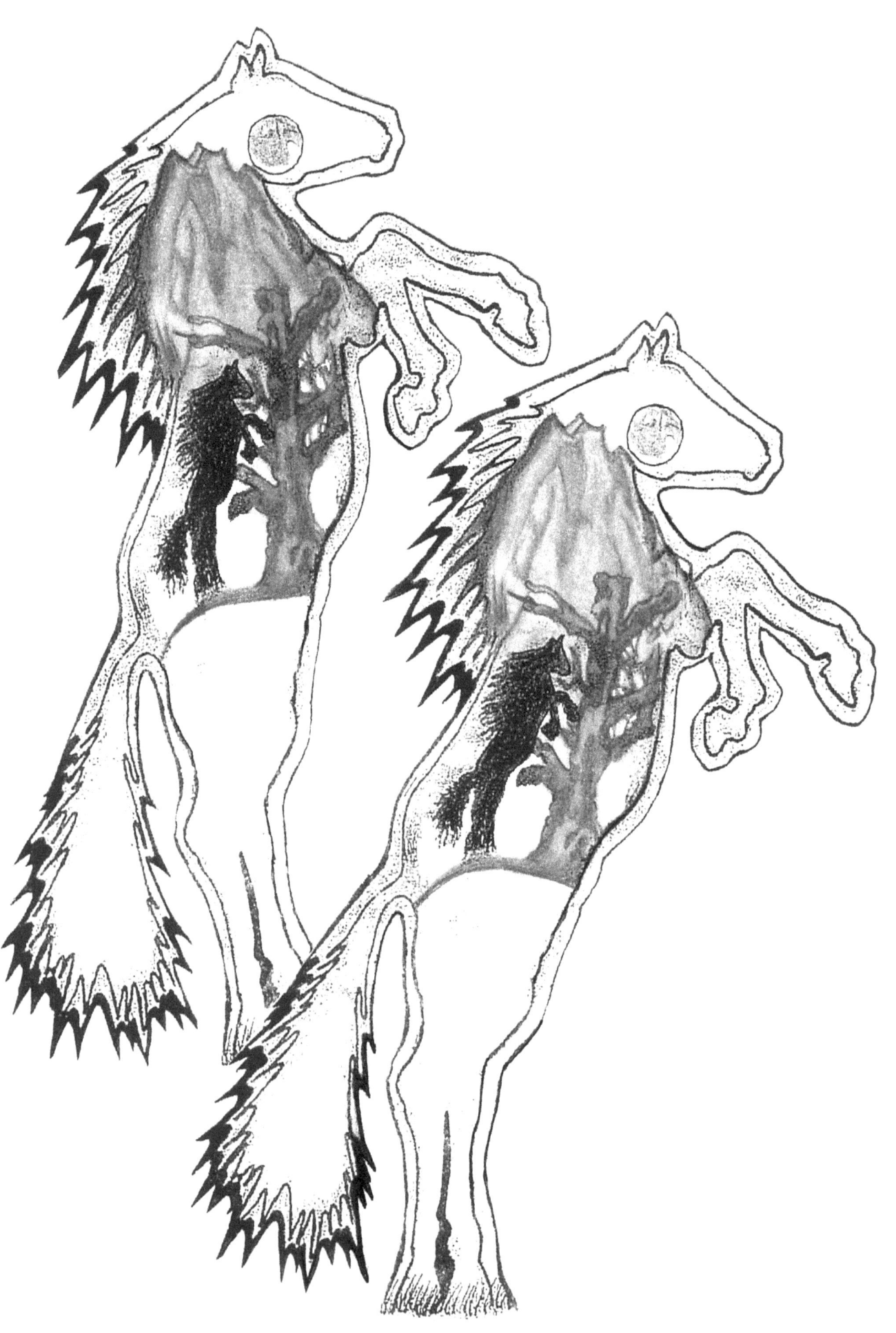

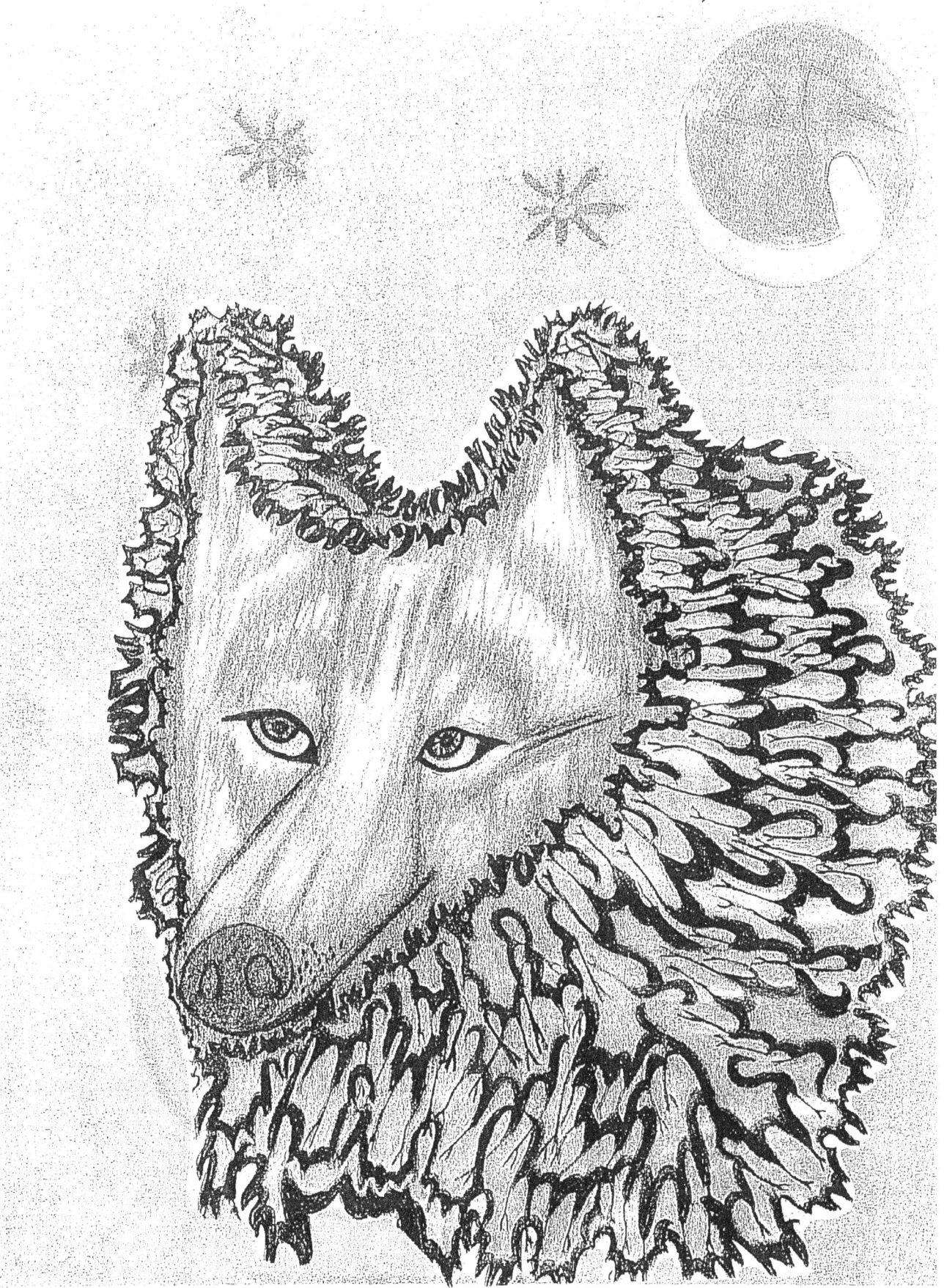

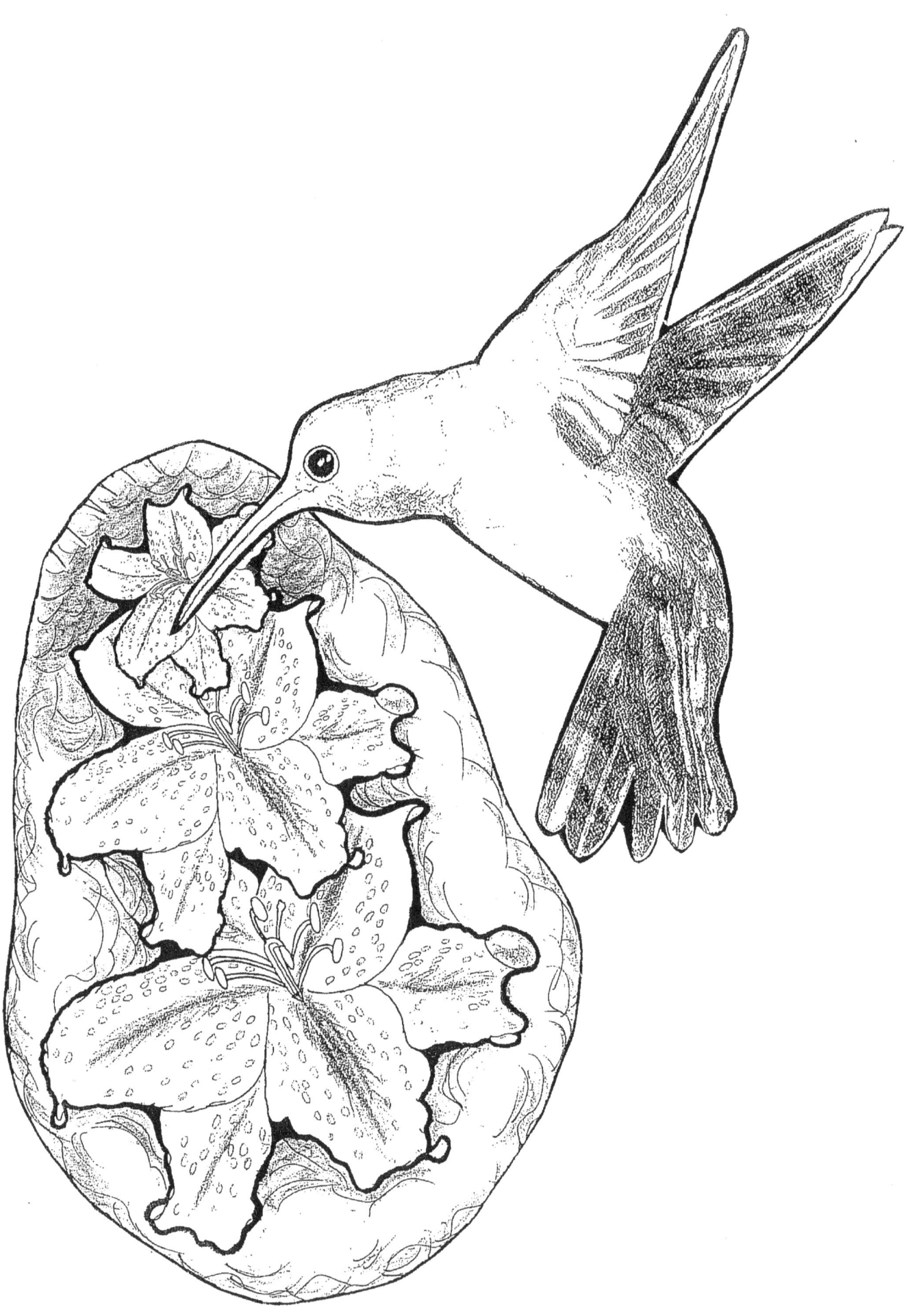

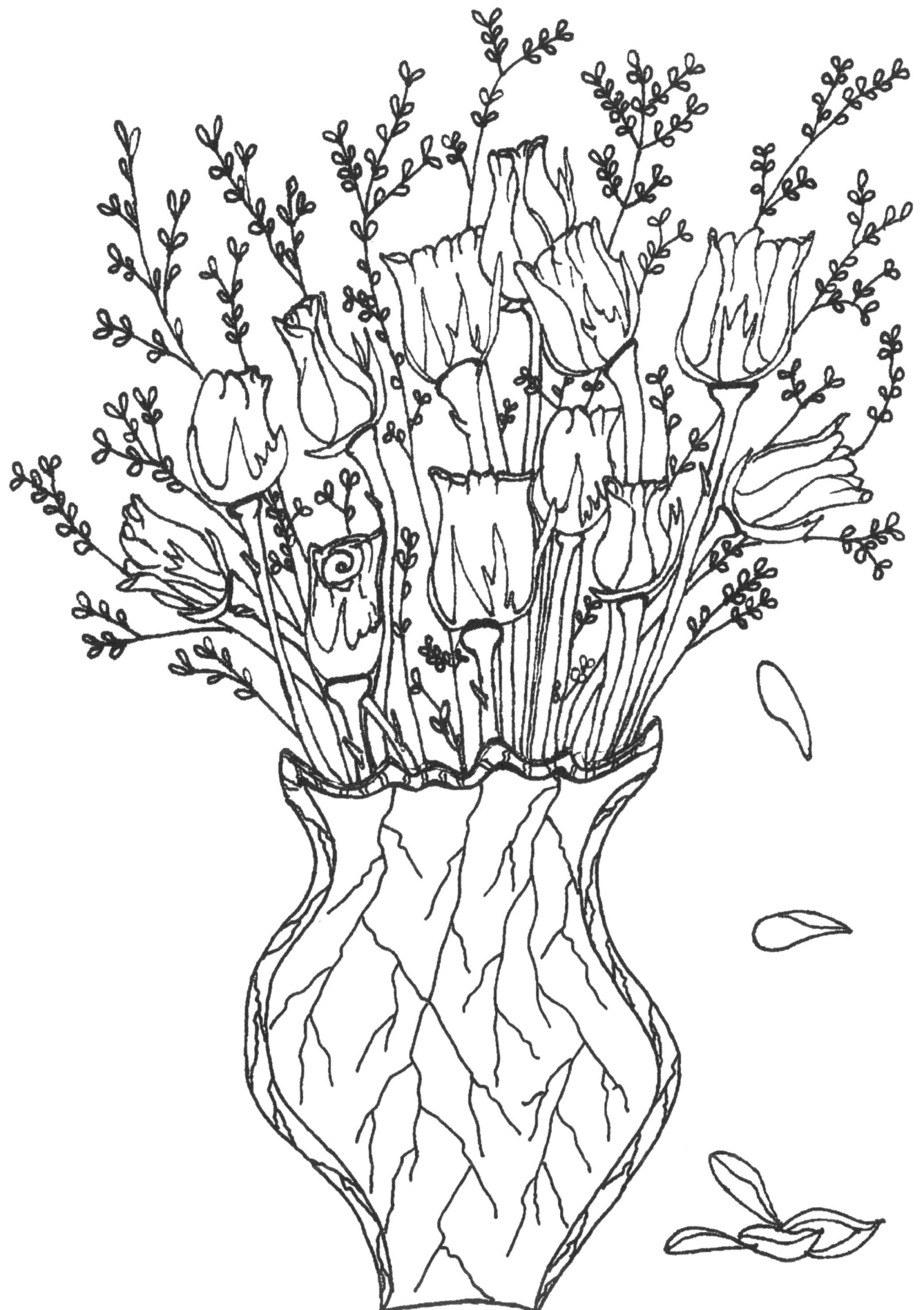

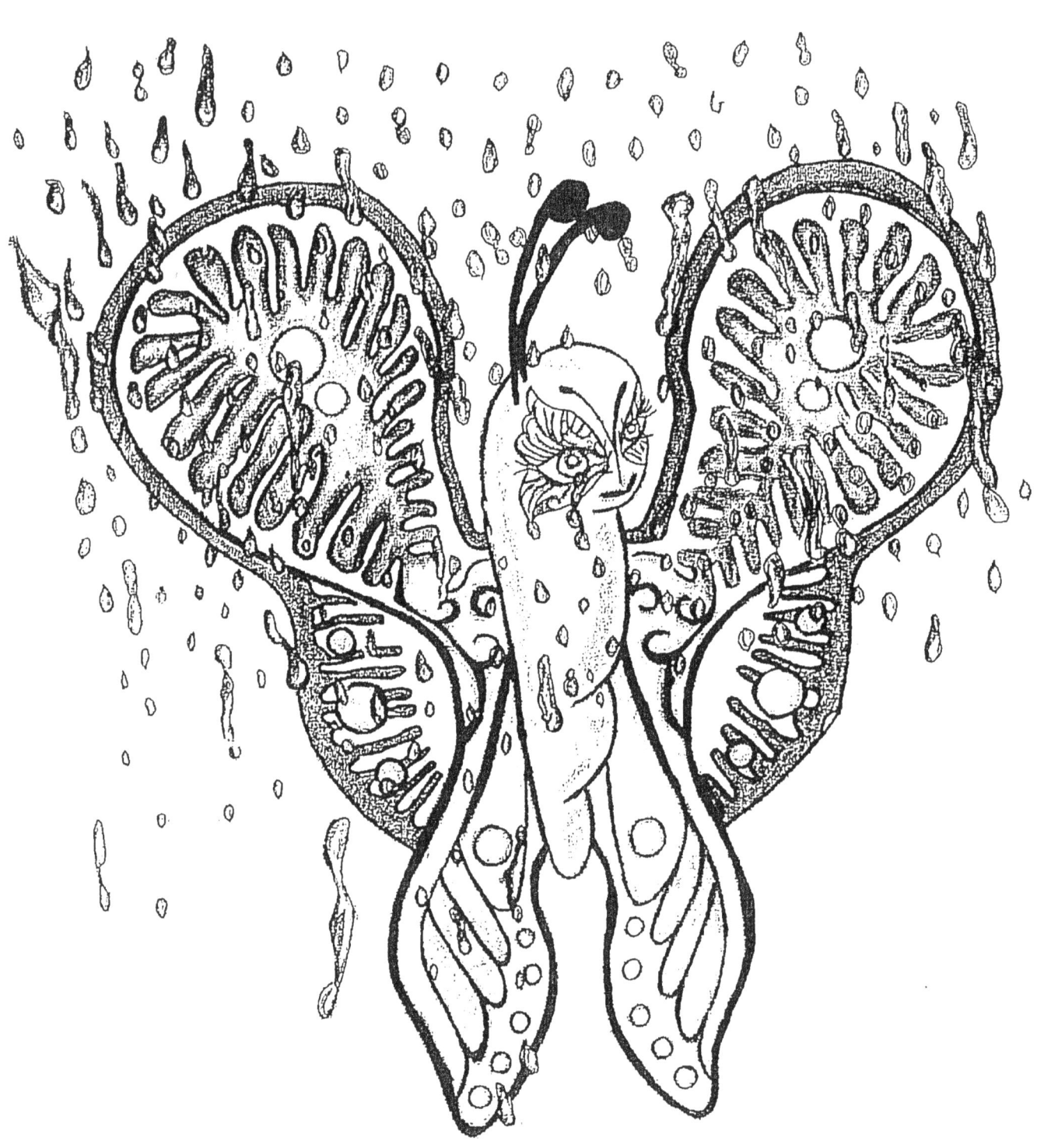

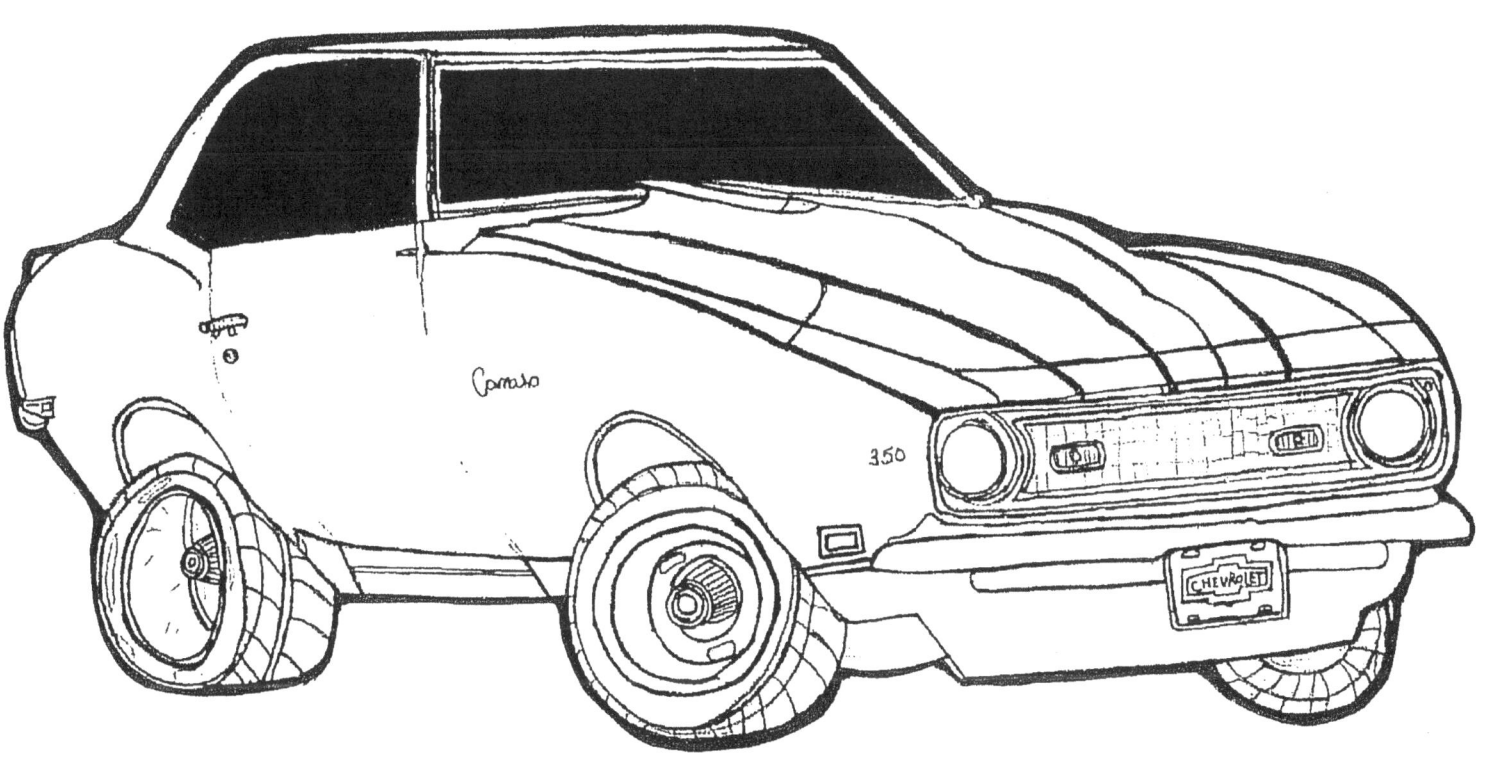

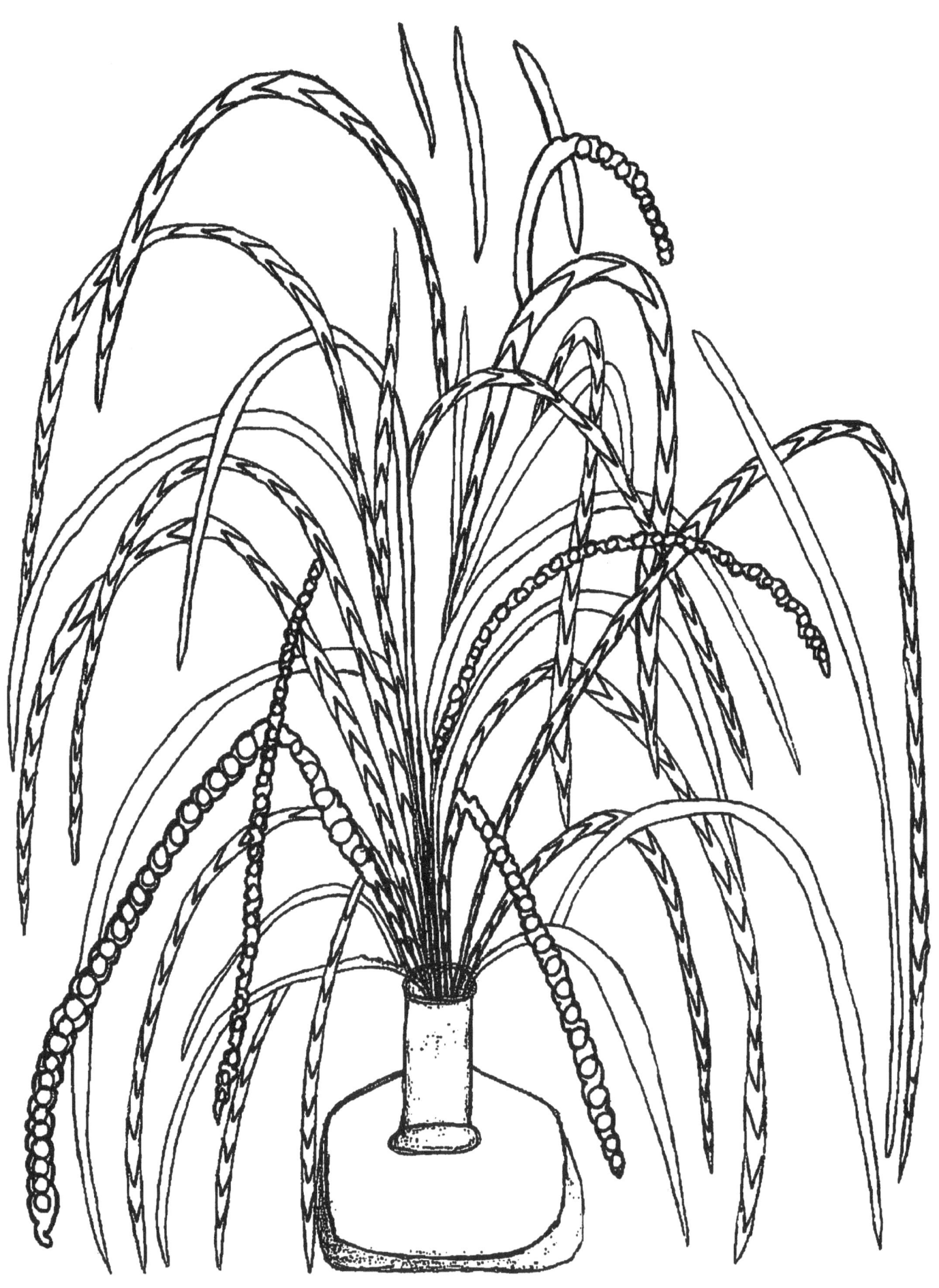

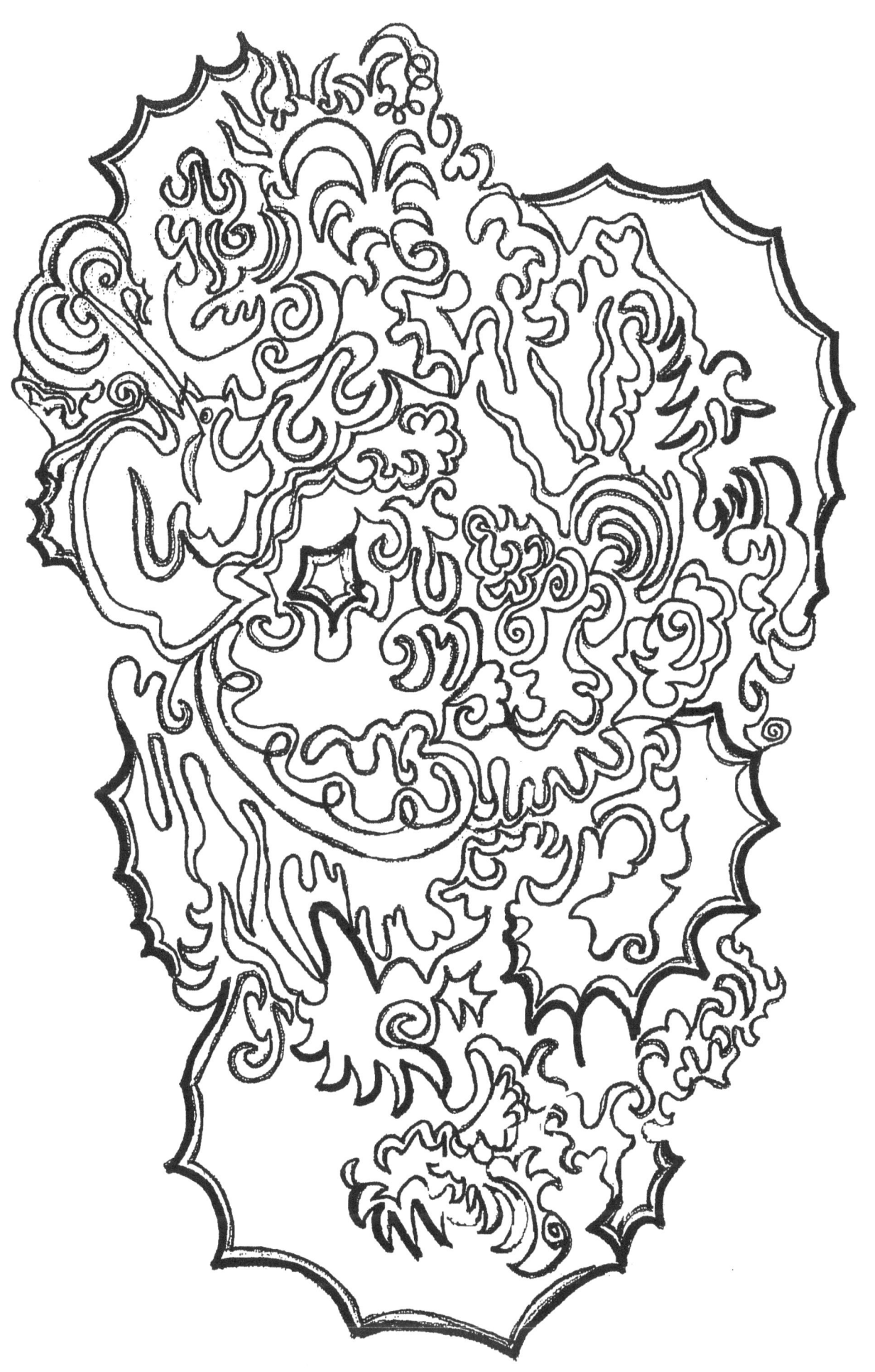

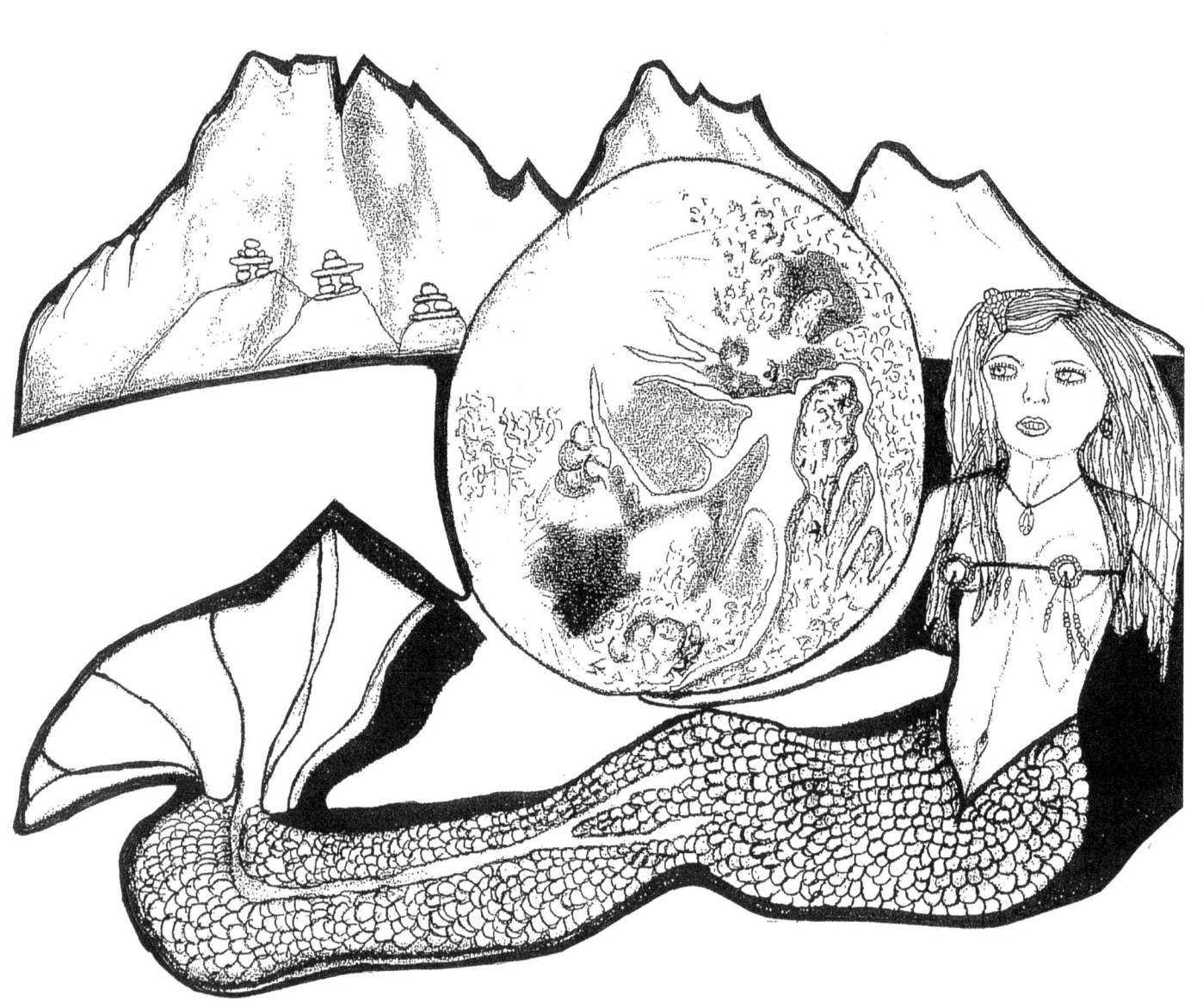

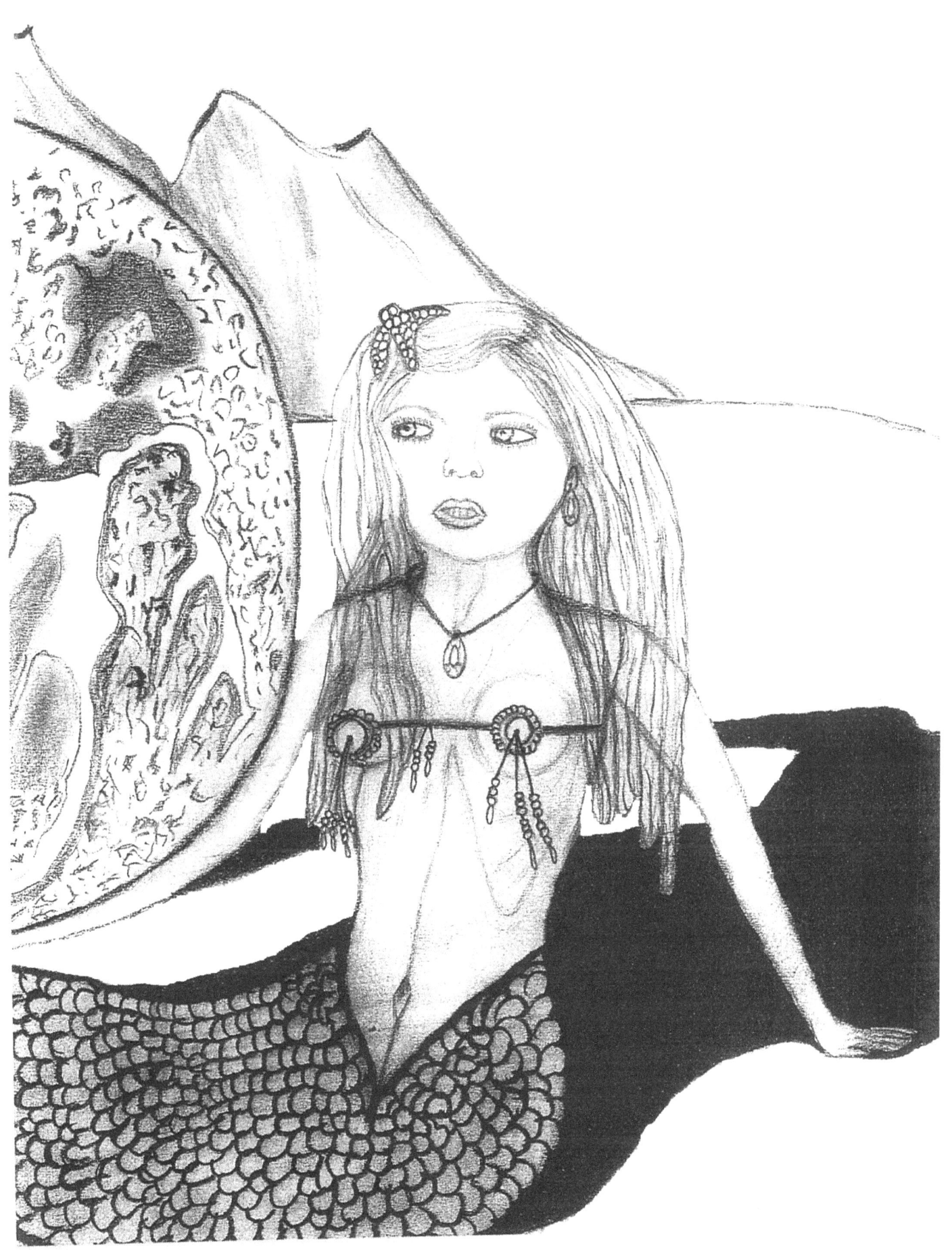

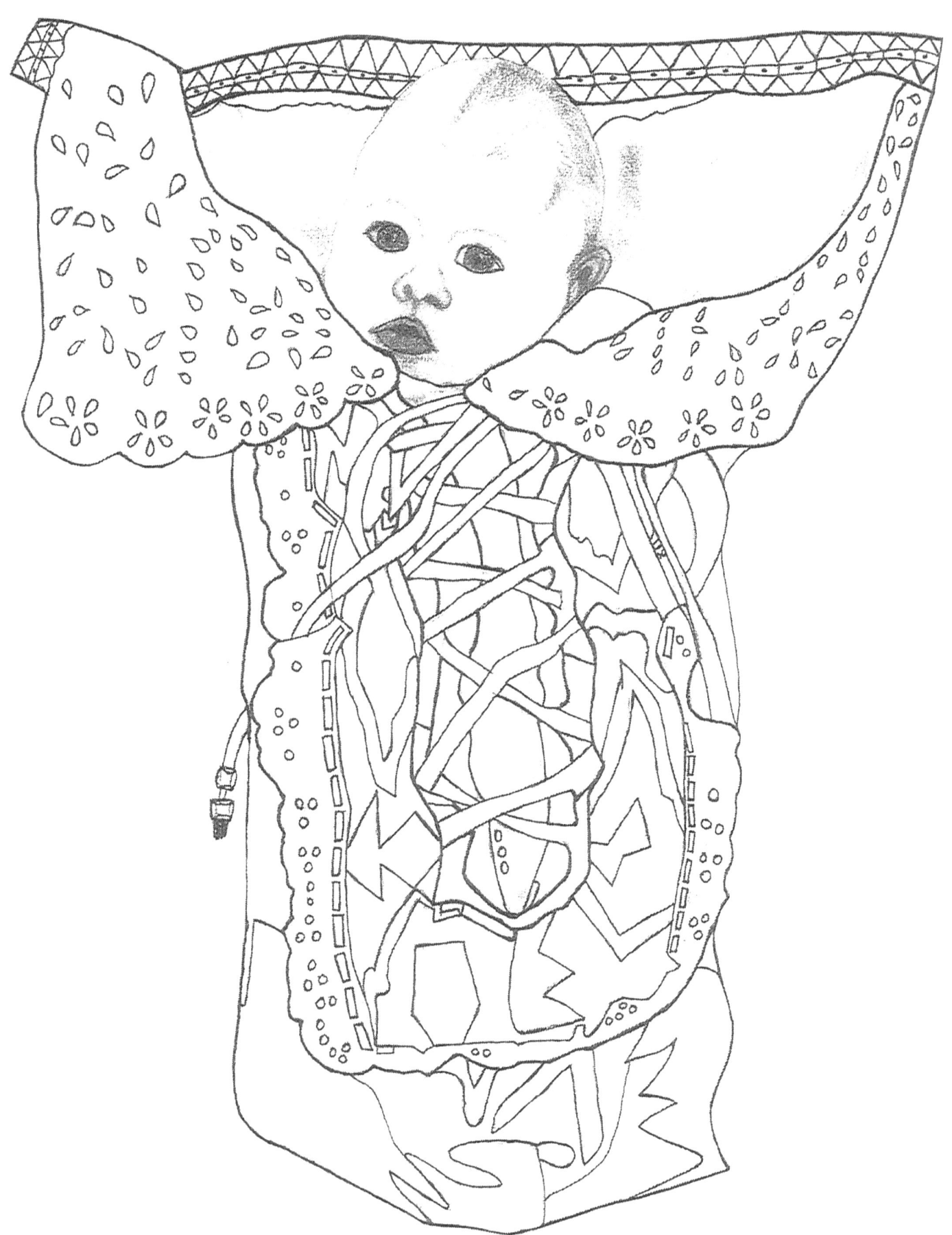

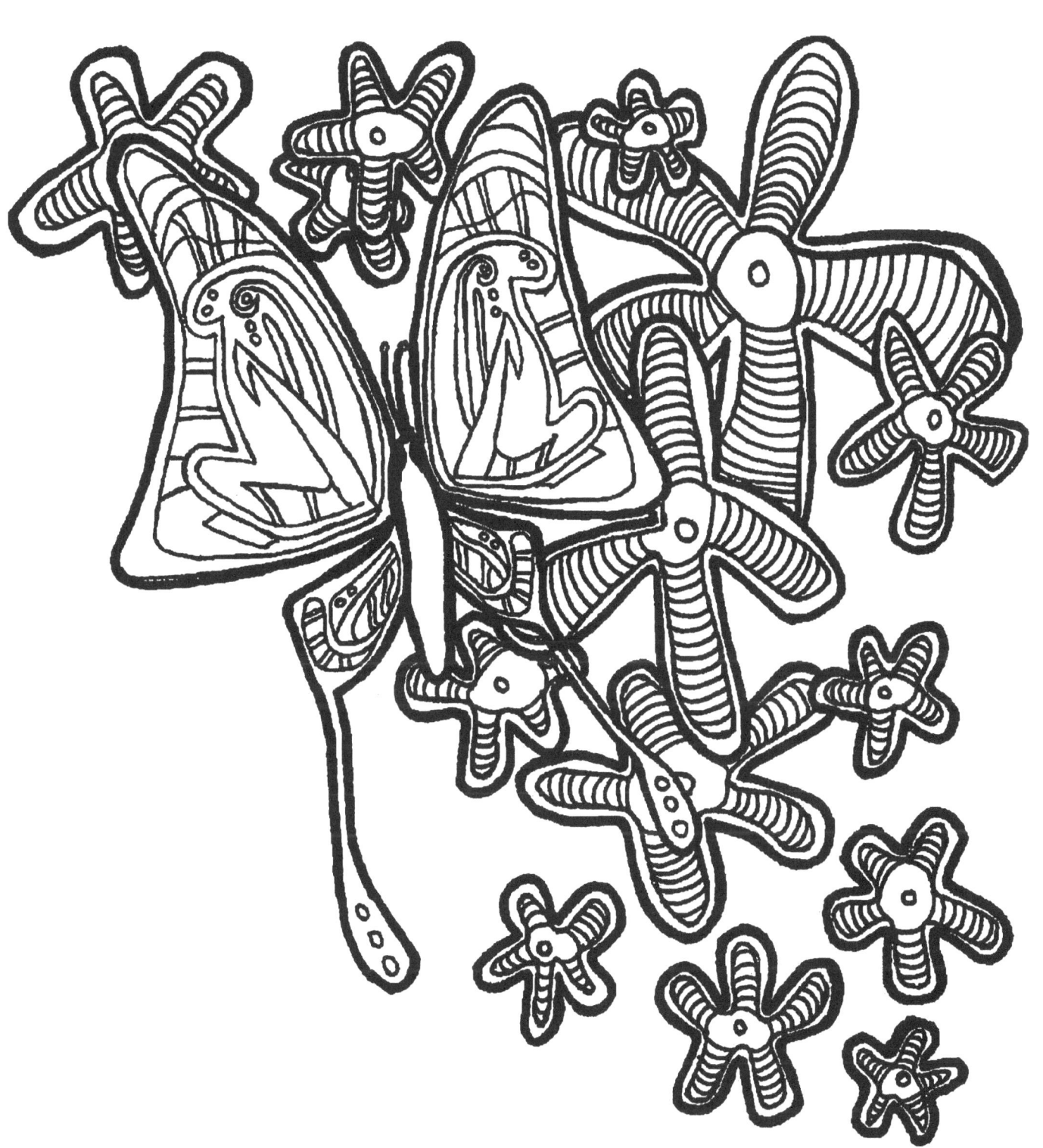

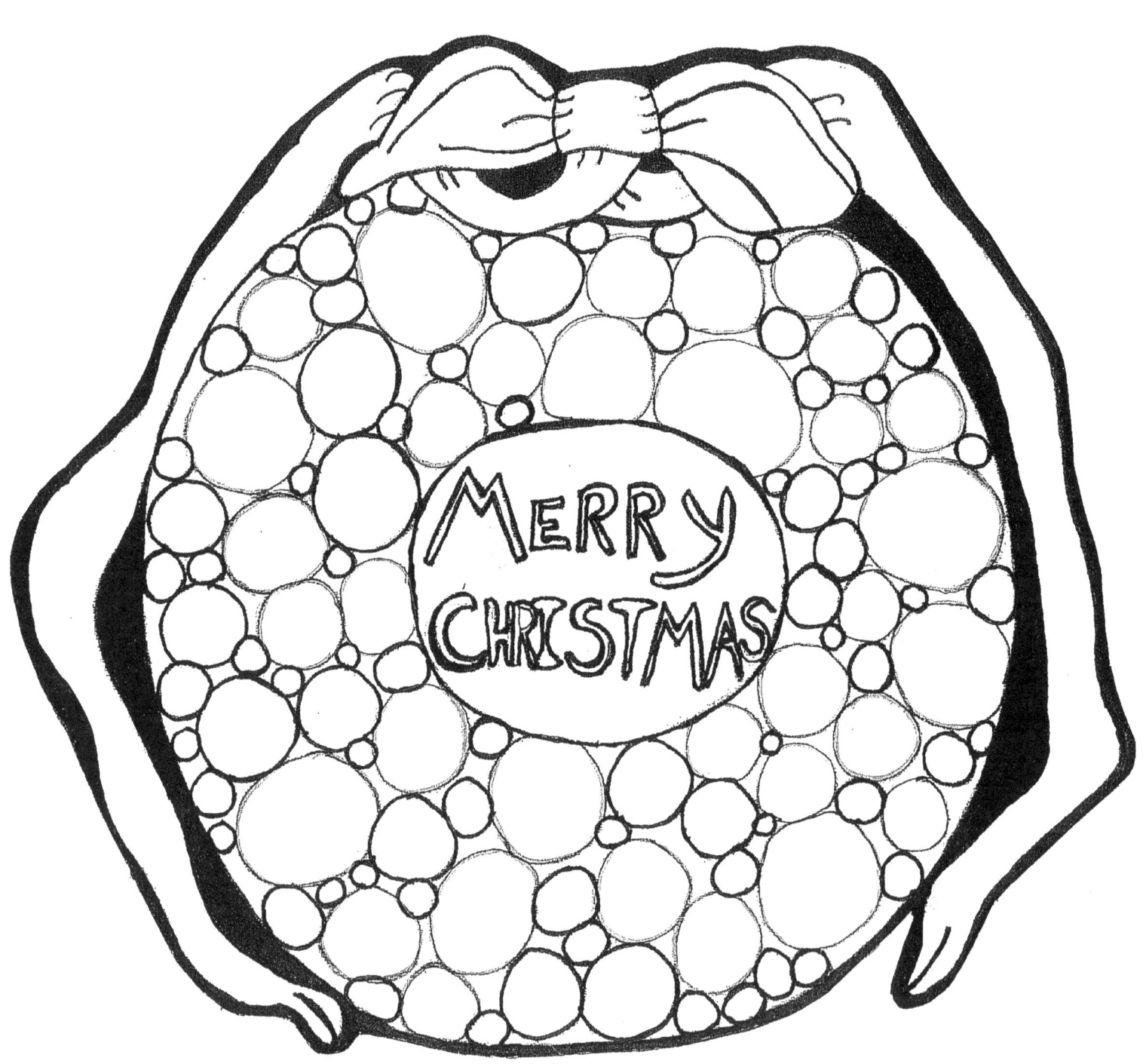

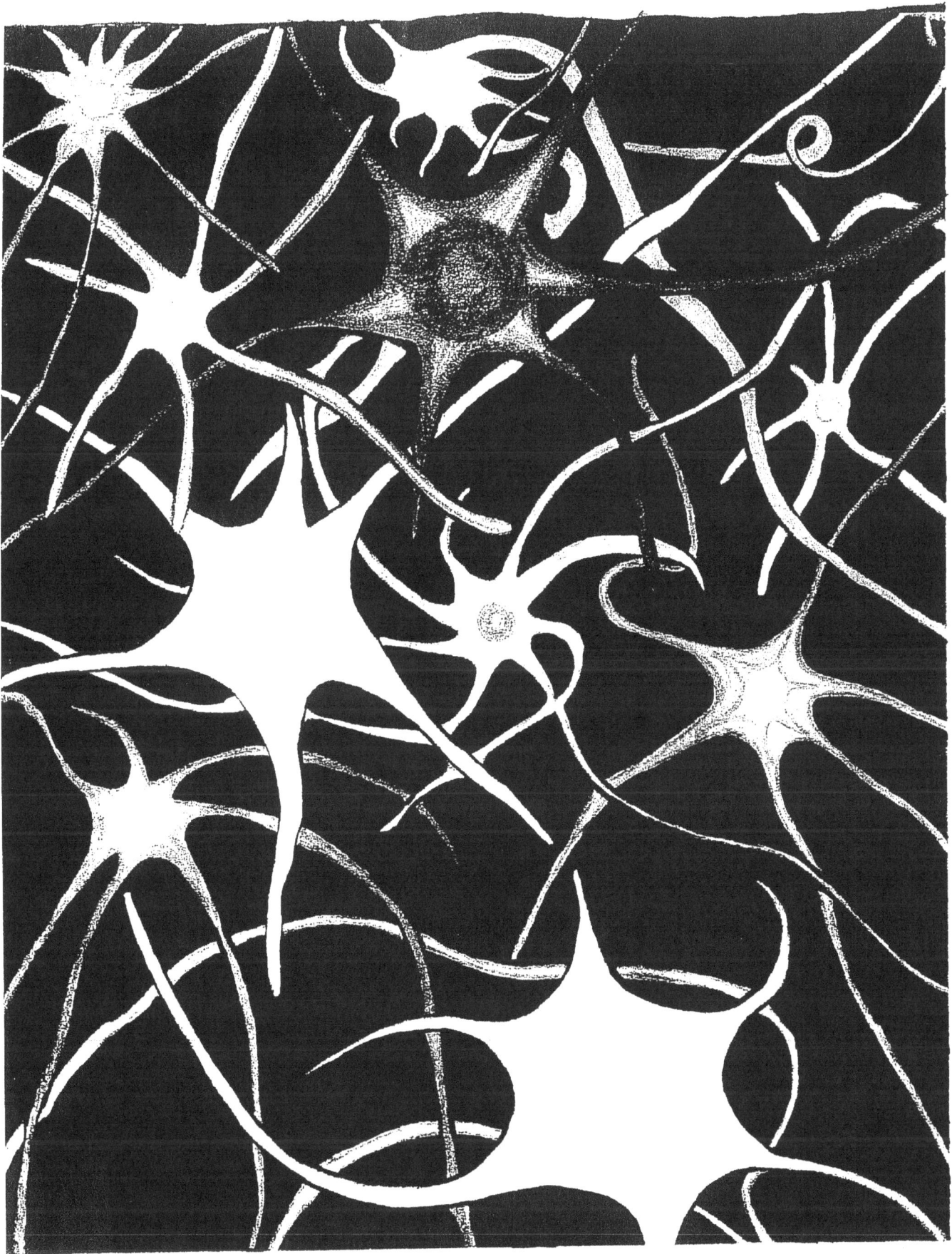

How This Book was
 Created....
Christmas season 2009
Stephanie, and I were searching
for that Unique Gift.
I wanted to find an Adult Coloring Book.
We had no success in finding one.
At that moment I realized I can
make a book.
I transformed some of my Art
Work, and some of Stephanie's..
And put a book together.
It's 2015, and I am Sharing
 my book with;
 All of you.
As I work on another book.
I hope you enjoy this one.
Special Thanks to my Dad; ALVIN..
Daughter; Stephanie..

 MARJORIE FLOHR
 2015.